Praying
in color

Praying
in color

Sybil MacBeth **Drawing a New Path to God**

portable edition

PARACLETE PRESS
BREWSTER, MASSACHUSETTS

2013 First Printing

Praying in Color: Drawing a New Path to God—Portable Edition

Copyright © 2013 by Sybil MacBeth

ISBN 978-1-61261-353-6

Library of Congress Cataloging-in-Publication is available.

ISBN 978-1-61261-353-6

10 9 8 7 6 5 4 3 2 1

Published by Paraclete Press | Brewster, Massachusetts | www.paracletepress.com
Printed in the United States of America

In memory of my mother, Sybilla Jane Bates Prouse,
who gave me my first prayers and a heart for God.

contents

Part 3 The Practice

Part 4 Using *Praying in Color* to...

Part 5 A Palette of Final Thoughts

Part 1

From Pen and Paper to Prayer

Chapter -5

Prayer Dilemmas

Here are some reasons that you might want to read this book. If any of these dilemmas describe your efforts at prayer, then you and I stand on some common, shaky ground.

- You make a list of the people for whom you want to pray and then don't know what to pray for.

- You can't sit still long enough to get past the "Our Father" or "Hello God" step.

- Your prayers feel more like a list for Santa Claus than a love letter to God.

- You fumble for the right words and deem the effort hopeless.

- You dump the contents of your heart and mind on God and then wish you hadn't.

You turn to a prayer book or the Bible for solace and guidance, and then fail to find the verse that describes your immediate need.

Your prayers feel too puny, too self-centered, too phony . . . or just somehow . . . inadequate.

You're bored with the same old prayers that you've said since kindergarten.

You ask that God's will be done, then cross your fingers and hope you can bear the results.

You promise to pray for others, and then forget who they are.

You can't wait for your prayer time to be over and done with.

You start to pray and realize that you're thinking about paying the bills.

Praying for others feels like checking off errands on a "to-do" list.

Your spirit and body reach a place of calm and stillness in prayer and then you fall asleep.

You want to like the act of praying, but it is more often obligation and drudgery than joy.

You're sure that everyone you know is a better and more effective pray-er than you are.

Chapter -4

Praying in Color

Praying in Color is an active, meditative, playful prayer practice. It is both process and product. The process involves a re-entry into the childlike world of coloring and improvising. The product is a colorful design or drawing that is a visual reminder of the time spent in prayer.

Now, before you slam this book shut with the panicky feeling that this is an exercise for artists, please wait. This practice requires no skill. I cannot draw a cat. Or a dog. Or anything else for that matter. Throughout my years in school, C's in Art were the blemish on an otherwise rosy-faced and squeaky-clean report card. My artist mother and grandmother could only sigh and wonder what had gone awry in the tossing of the genetic salad.

But in spite of artistic deficiencies, I have always loved color. The stadium-seating of the 48 crayons in the Crayola box, the sweet smell

of paper and wax, and the feel of the thin cylinders rolling around in my hand were an early experience of worship. A little altar was set before me with all those colors waiting to evangelize the world. So much potential for beauty and transformation—it seemed a terrible injustice that what I drew was so ugly.

The irony and miracle for me is that now, in my adulthood, God has taken one of my passions—color; combined it with one of my inadequacies—drawing; added it to my antsy and improvisational personality; and given me a new way to pray. "My grace is sufficient for you, for my power is made perfect in weakness" (2 Cor. 12:9 NIV). I think I have an inkling of what Paul felt when the Lord spoke those words to him.

So I repeat; no skill is required. If you are a visual or kinesthetic learner, a distractible or impatient soul, a word-weary pray-er or just a person looking for a new way to pray, I hope you will find this practice helpful. If not, I hope it will simply jump-start some new prayer ideas that work for you.

Chapter -3

Prayer Frustration

I am a mathematics instructor by vocation, a dancer and doodler by avocation, and a pray-er by birth. My mother breathed prayers into me from the moment I was born. While God "knit me together in my mother's womb" (Ps. 139:13 NRSV), my mother said "Amen"—let it be so—with every stitch. As a result, I have no memory of a God-free life. My earliest childhood memories are of my mother sitting on the edge of my bed, stroking my hair, and reciting the Mary Baker Eddy prayer for children:

> Father-Mother God,
> Loving me, —
> Guard me when I sleep;
> Guide my little feet
> Up to Thee.

I liked the prayer. It was simple to say and easy to visualize. The fact that I saw myself upside down with my toes wiggling toward God was not a problem. Since I was a footling breech at birth, it

7

seemed the natural way to approach God. The prayer was also less scary than the one that both my little Catholic and other Protestant friends said—"and if I die before I wake, I pray the Lord my soul to take." Feet I could understand, but death and souls were the stuff of the ghost stories my big brother told.

With prayer so deeply ingrained into my being, I should be an expert. But, if Prayer is a credit course in the kingdom of heaven, I'm in trouble. The report card grade of C- would probably say: "not enough detail, wandering attention, too many clichés, too little time and effort, too self-focused, too much fidgeting, too much whining. . . . "

I've never been much of a prayer warrior; I cannot fire out eloquent, television-worthy prayers. Instead, I'm more like a prayer popper. I pray a lot, but in fits and spurts, half-formed pleas and intercessions, and bursts of gratitude and rage.

Although I am no longer a member of the church that soaked my childhood in prayer, I cling to one of the principles that I learned there: that prayer is an every-moment activity—not just on Sundays or at the dinner table or at bedtime. Prayer is the glue that holds all of the pieces of life together in a spiritual whole. It reminds us of who we are and whose we are. My early Sunday school teachers and my mother took seriously the directive from 1 Thessalonians 5:17: "Pray without ceasing" (KJV). Other translations and versions of the Bible use similar words: "pray constantly" (RSV), "pray continually" (NEB), "*sine intermissione orate*" (LV)—which might be translated *without intermission speak*. In any language, the challenge is clear.

Although those words could feel like an order for an impossible mission, they seem to me more like a personal invitation. *Be with God here and now; the party has begun.* But as with all party invitations, my anxiety rises. "What shall I wear?" The clothing in this case is the kind

Praying in Color

of prayer I will pray. That's why prayer forms fascinate me. I know about centering prayer, contemplative prayer, walking prayer, healing prayer, soaking prayer, meditation, praying in tongues—I took the workshops and read the books. I've dabbled in all of them. But a short attention span and a proclivity for daydreams hamper my efforts. Five or six sentences or breaths into a well-intentioned prayer, I lose focus. The ungraded math papers on the desk noodle their way into my thoughts. Anxiety about my inadequate parenting joins in the conversation. The words of my prayers and the words of my distractions collide in an unholy mess. On a good day, when words flow with more ease, I become so impressed with my successful articulation that I become the center of my own worship. It is not a reverent sight.

With feelings of guilt and inadequacy, I've thought about bagging the whole prayer exercise. But I have a priest friend named, appropriately enough, *Merry*, who encourages me: "If it's worth doing, it's worth doing poorly," she says. Besides, there's that deep, unrelenting hunger to know God. Prayer, even below-average prayer, is my feeble effort to get acquainted.

Chapter -2

Prayer Popping

As a prayer popper, I stay in touch with God. I send lots of spiritual postcards. Little bits and bytes of adoration, supplication, and information attached to prayer darts speed in God's direction all day long. A friend of mine calls postcards "maintenance mail."

Instead of waiting to write a Pulitzer Prize-winning letter, she sends frequent postcards to maintain the relationship. It is a good means of communication, certainly better than nothing. But thinking that any relationship will grow when I'm only willing to commit two or three minutes of time or 2 inches by 3 inches of space is delusion. How often can I receive postcards from a friend that say, "All's well, hope you're okay, thinking of you, back soon," and believe that I am really important? Though God probably appreciates my regular check-ins, "Hi God, Bye God," doesn't feel much like a formula for creating intimacy or a relationship with much depth.

For me, intimacy requires more than a minute here and there; it requires time. And it requires time after time of time. The word *intimacy* has its roots in an alteration of the Latin *intime* (Merriam-Webster Online). Although there are no etymological connections, adding a space results in the sweet coincidence of *in time*.

Since words elude me when I need them most, I learned long ago that I cannot count on *quality* time with God when I want to pray. I need *quantity* and regularity. Quality is not something I can predict. My husband, Andy, and I might schedule an elaborate evening out with candles and a gourmet meal, but there is no guarantee that we'll have a wonderful time. Much of our intimacy has been created in the daily-daily of spending time together—chopping onions and peppers side-by-side in the kitchen, reading together on the couch, sitting on the front step watching our sons ride bikes, and making plans for our life together.

So I need a way to pray that gives me time. I need a way to pray that does not require lengthy, prize-winning words. I need a way to pray that suits my short attention span, my restless body, and my inclination to live in my head.

Chapter -1

Praying for Others

The fact is that I feel quite free to make a mess of my personal prayer life; but when someone says, "Please pray for me," they are not just saying "Let's have lunch sometime."

They are issuing an invitation into the depths of their lives and their humanity—and often with some urgency. They are publicly exposing their vulnerability, sorrow, and fear. Something about their life is so out-of-control that they call upon the likes of me for help. I warn them that sometimes the people I've prayed for have died. It's a risk.

There's also the risk that instead of praying for them, I'll just worry about them. And worry is not a substitute for prayer. Worry is a *starting place*, but not a *staying place*.

As a *starting place*, worry is a psychophysical signal that something is wrong. Like guilt, it lets me know that something is askew or not quite right in the universe. I'm not a proponent of guilt-busting or even worry-busting. If I chase guilt and worry away too quickly, I miss the message they bring. They arrive uninvited, but I may need them to stick around for a while. They are my wake up call, my psychic and spiritual reveille. Both guilt and worry can trumpet, "Get off your duff, get out

and do something, get your act together, get your hands off, get out of this situation. . . ." But almost always they say, "Get on your knees; this is more than you can handle alone." Worry invites me into prayer.

As a *staying place*, worry can be self-indulgent, paralyzing, draining, and controlling. It conjures up the dark side of my imaginative gifts and consumes my energy. It is no less evil or titillating than pornography. When I take worry into prayer, it doesn't disappear, but it becomes smaller. I see it for its true self—an imposter that masks itself as action and lassoes me into inaction. Brought into prayer, it sits next to me and whimpers for its former place of honor and power. When I focus on my prayer, on that conscious effort to engage the presence of God, worry heels, stays, and sometimes even rolls over and dies.

So when people ask for my prayers, I take a deep breath, put the choke chain on worry, and walk, leash in hand, into that place called prayer. When I ask people to pray for me, I hope they will do the same. I don't want them to worry about the details of my request. Obsessing about my sorrow, "tsking" about my wayward children, peeping through the keyhole of my confessions, fantasizing my diagnosis and prognosis, or writing my obituary is not their task. Their task is to fill the universe with good thoughts, to wrap me in God's love, to give me hope, and to intercede for my healing. I want them to reconnect my hands and heart with God's when I'm too fraught with fear or sadness to do it by myself. When I pray for others, I assume they are asking for the same respect. I assume they want me to hold my obsessive and voyeuristic thoughts at a distance as well.

It's a daunting responsibility to say "I will" to a prayer request; and it is with some caution and trepidation that I make the offer, "Would you like me to pray for you?"

Chapter 0

Praying in a New Way

About ten years ago and over a two-semester period starting in September, I had a multitude of family, friends, and colleagues stricken with a litany of terrible cancers—lung, brain, breast. The amount of disease and suffering within my circle of friends was overwhelming.

Did I pray? I tried. I shot a daily quiverful of pathetic little prayers to God for healing, remission, comfort, courage, long life, miracles, God's will and a host of other outcomes—all the while knowing that my prayers were not the deal breaker or a magic bullet for a cure. But I also knew that my worry and outrage created an aura of fear and negativity that threatened to overpower my faith. My friends deserved better support than just "praying scared."

By May, at the end of the school year, I had half-a-dozen friends and family members—Sue, Chuck, Peter . . .—on my critical prayer list. With three months of sabbatical from my work as a math professor, I retreated to the back porch of my house, determined to catch up on nine months of a somewhat neglected spiritual life. With no papers to

grade and no lessons to prepare, I was also free to indulge in my number one form of meditation, relaxation, and procrastination: doodling. One morning, I lugged a basket of colored pencils and markers to the center of the porch's glass-top table.

Now remember, I have never been able to draw a cat, a dog, or anything else for that matter. But I love color and shape and movement. Improvisational drawing, a.k.a. doodling, allows me to combine those loves on paper. So I opened a pad of Manila paper and started to draw. I doodled a random shape into existence with a thin black pen. Without even realizing it, I wrote a name in the center of the shape. The name belonged to one of the people on my prayer list. I stayed with the same shape and the name, adding detail and color to the drawing. Each dot, each line, and each stroke of color became another moment of time spent with the person in the center. The focus of the drawing was the person whose name stared at me from the paper.

When the time seemed right, I moved to a different place on the page and drew another shape with another name in the middle. I embellished the new shape with detail, lines, and color. I drew new shapes and names until friends and family formed a colorful community of designs on the page.

To my surprise, I had not just doodled, I had prayed.

The entire prayer time was silent and wordless. I felt no need to supply a pious or pleading monologue. The feeling of despair and discouragement and my usual urgency to flee from the sickness and distress of others were all absent. I had thought "of" each person as I drew, but not "about" each person. The details of their prayer needs were spared and I could just sit with them in a variation on stillness.

When the drawing was finished, there was a visual record of my prayers. The images stayed in my mind and I carried them—and

sometimes the actual page—with me wherever I went. Now I had a visual prayer list that I was less likely to lose in the detritus of my car or purse. The yellow and green "Sue" prayer popped into my mind at other times during the day, and I prayed for her on the spot. I'd see Peter in purple and gray and know that God was swaddling him in a "coat of many colors." I saw the whole array of my loved ones on the page and knew that, in spite of my fear and faltering words, I could hold them in prayer.

Part 2 Getting Started

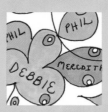

Chapter 1

Supplies

You will need paper and colored markers or pencils. I also use a thin black, roller-point pen to make the initial outlines and add detail. I usually draw in a hardback marble composition book in which I keep my daily journal. If you are distracted by the lines or want to be able to fold up your drawing and drop it in your pocket, purse, or briefcase, buy a drawing pad from an art supply store or a discount department store. I close my eyes when I pass the fancy leather-bound or handmade journals of paper. They can be so beautiful that my intimidation level prevents me from writing or drawing in them at all. Computer paper, newsprint, or even the back of an envelope will work in a pinch.

Markers and colored pencils are available at the same stores as the paper. I avoid washable markers because they tend to smear. If you want

to purchase nice markers or pencils, invest in brands at the art supply store. Many of the people who work in these stores are artists who have experience with the supplies. They will advocate for their favorite brands of markers or pencils and tell you the pros and cons of each kind. These items may also be purchased online. The markers I use are permanent and come in almost two hundred colors. The pencils contain soft lead and come in so many lush, beautiful colors that they forgive any inadequacy in my drawing. Both markers and pencils come in sets, but you can also buy them individually so that you can make your own color choices. Start with twelve—a discipleship of markers—or if you're more daring, thirteen—the Judas dozen.

You might ask, "Why do I have to spend money to pray? Or why can't I use crayons?" The answers are, of course, "You don't have to" and "You can." But I can only testify to my own experience: Having decent supplies (but not elegant or exotic ones) makes drawing more satisfying and aesthetically pleasing. If the cheap markers smear all over the paper, get all over my hands, and the result is really ugly, I'm likely to give up. Crayons can work, but I'm not enough of an artist to manipulate them well.

Those may seem like superficial and unspiritual reasons, but that's where I start. I'm distracted and unskilled and I need a bit of gratification to stay on task. Buy the supplies you need to maintain your interest and focus.

Doodling Vocabulary

In case you haven't doodled since elementary school or never did, here is a mini doodling lesson.

Draw:

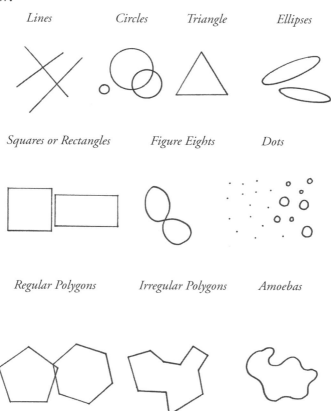

Lines Circles Triangle Ellipses

Squares or Rectangles Figure Eights Dots

Regular Polygons Irregular Polygons Amoebas

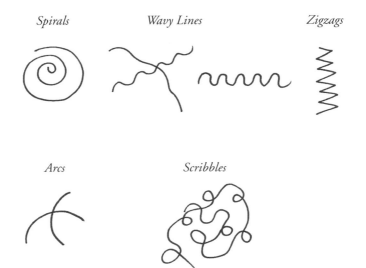

Spirals *Wavy Lines* *Zigzags*

Arcs *Scribbles*

Combine some of the above shapes and strokes together:

Polygons with Arcs *Self-Repeating Shapes* *Triangles with Circles*

Scribbles with Squares

Figure Eights with Lines

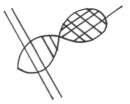

Amoebas with Dots

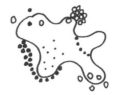

The point of showing these options is just to give you permission to draw whatever you want. These are suggestions of where to start. Let your hand take you where it wants on the page. In other words, there is no teacher looking over your shoulder. Just start drawing. It can even be ugly. Your hand will figure out what movements and shapes it likes to make. If you happen to have some artistic skill and like realism, go ahead and draw boats, stop signs, trees, or whatever.

Chapter 2

Time and Place

This prayer form can take as little or as much time as you have or want to commit. A minimum amount might be fifteen minutes. I find a half-hour works well. Any time of the day will work. If I draw in the morning, I can carry the names during the day. If I pray in color at night, I carry a feeling of blessing with me to bed. I can use my prayer chart the next day as well.

A quiet room with a table is ideal. The reality, however, is that true quiet is hard to come by. I have prayed at a table on my back porch (my ideal spot), but also in the car (as a passenger), in an airplane, on the couch, in a coffee shop, or just about anywhere. A clipboard turns any place into a prayer corner. In Matthew 6, Jesus advises us: "But when you pray, go into your room [or closet] and shut the door . . ." (Mt. 6:6 RSV). The action of hunkering down over a pad of paper tends to create its own prayer room or space and allows me to shut out extraneous activity.

Setting up the space can also be part of the prayer ritual. Men and women prepare an altar for worship and Communion by arranging flowers, spreading the fair linen, placing the chalice and paten on the table, and lighting candles. Find a simple way to create a makeshift prayer place. Light a candle. Walk outside and clip a flower or something green to put in a small vase. I clear a space, bring out the markers, and lay out the paper. These basic actions announce to my mind and body my entrance into a place set apart for something special. If prayer is the way that humans rap on the door of the Creator, then colored markers are my brass knocker. The markers and paper set the stage for my prayer time.

Once you gather your supplies together, you might want to segue into prayer using one of the following ideas:

 Recite or read a passage from Scripture. One that seems applicable to this practice is Romans 8:26: ". . . the Spirit helps us in our weakness; for we do not know how to pray as we ought, but that very Spirit intercedes with sighs too deep for words" (NRSV). Say it several times.

 Sing a verse of a favorite hymn.

 Say a prayer to gather the pieces of your body, mind, and spirit together.

 Sit in your chair and breathe for a minute or two.

 Do a few minutes of exercise. Stretch. Reach to the sky, touch your toes. Bend your knees. Wiggle your hips. Invite your body into prayer with you.

 Take several deep breaths. Let out a noisy sigh after each one. With each exhale, release the "To Do" list.

 And . . . if none of those ideas appeals, just pick up your pen, your markers, and begin to pray in color.

Remember, this is an all-day prayer event. Drawing is only half the prayer. The other half is transporting the visual memories—either in your mind or on paper—so you can pray throughout the day. The images are the visual alarm clock or Sanctus bells that remind us to pray.

Part 3 The Practice

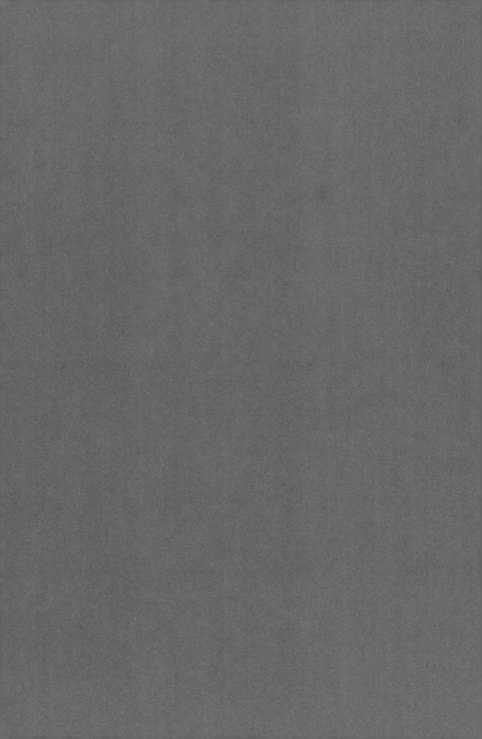

Chapter 3

The Steps

Draw a shape on the page—a triangle, trapezoid, squiggly line, or imperfect circle. Write the name of a person for whom you want to pray in or near the shape.

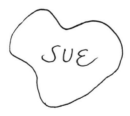

Other ways to begin . . .

Write "God," "Jesus," or one of the infinite names for the Almighty in the first shape. This can serve as a reminder that God is ever-present in your prayer and your work.

Write your own name in the shape. Sometimes, the first people who need prayers of intercession are ourselves.

Leave the first shape empty with the idea that the mystery of God is in the midst of the prayer.

Add detail to the drawing. This might be dots, lines, circles, zigzags, or whatever your hand wants to do.

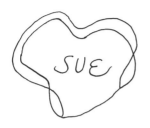

Don't analyze your next stroke too much. Dismiss the art critic from the room. This is not about creating a work of art; it's about creating visual images for the mind and the heart to remember.

Think of this as kinesthetic improvisation, a kind of praying in tongues for the fingers.

Continue to enhance the drawing. Think of each stroke and each moment as time that you spend with the person in prayer.

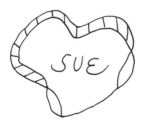

The written name and the emerging picture may evoke words and thoughts for the person. They add a new layer to your prayer experience.

Words, however, are unnecessary. Sometimes, we do not know what to say; the mere act of sitting with this person and keeping them as the focus of our intention can be as powerful as words.

I try not to insert words into the process. It seems to give my mind the "inch" that it needs to spin "miles" of extraneous thought.

Keep drawing until the image feels finished.

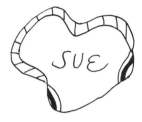

At some point, your mind will probably wander. In *Seeds of Contemplation*, Thomas Merton said, "If you have never had any distractions, you don't know how to pray."[1] Distractions are as much about being human as hair and heartaches. Make no judgments about your ability to pray based on their uninvited appearance.

Repeat the person's name to yourself as a way of corralling distracting thoughts. Think about the face or the entire person as if you were sitting with him or her in conversation.

Add color to the picture. Choose colors that will stay in your memory, that you particularly like, or that remind you of the person for whom you pray.

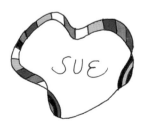

Try various pens, markers, or pencils. One person discovered *gel* pens. They come in an assortment of colors and are easy to use.

31

When the drawing and praying for the first person are completed, move to another space on the page. Draw a new shape or design to create a place for the name of a different person.

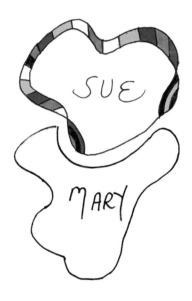

When you move your focus from one person to the next, you can, if it seems appropriate, offer a closing verbal prayer, an "Amen," or "I'll be back."

If the needs and concerns of the first person are particularly great, take several deep breaths to release any anxiety that you might carry to the next person. Or stand up for a moment and physically shake away those cares.

Sometimes I move directly from one person to another, knowing that we are connected in our pain and in our joy.

Repeat the process of drawing. Add detail and color the same way you did with the first person.

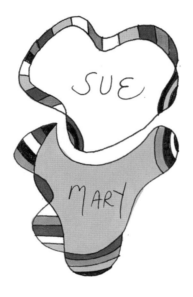

Praying for others is called *intercessory* prayer. When we offer intercessions, we are asking God for a change of direction in the present course of someone else's life. This might be the healing of their physical body, the reconciliation of relationships, or any other way in which their life is out of kilter. When we pray for others we become part of God's compassion modeled for us by Jesus.

Intercessions are also appropriate for countries, political issues, world crises, or even pets. Your entries might include any creatures or collections of humanity that are in your mind or on your heart.

Add a new person to the prayer "list."

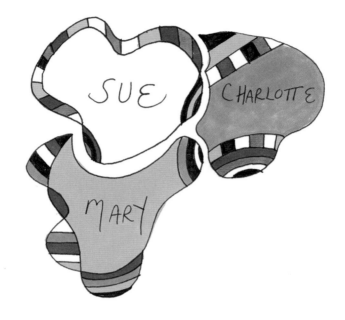

In the process of this wordless prayer form, daydreams and distractions will probably enter your mind and demand center stage. Notice them, but don't dance with them. Refocus on the person for whom you pray.

If a thought returns more than once, write a single word on the page to remind you to address it later. If it's an obsessive thought, think of it as bathed in the colors of your prayers and not able to control you. If it's a task or chore that's calling you, write a one-word reminder so you can release it for future attention, but not forget it.

Add another person to the drawing.

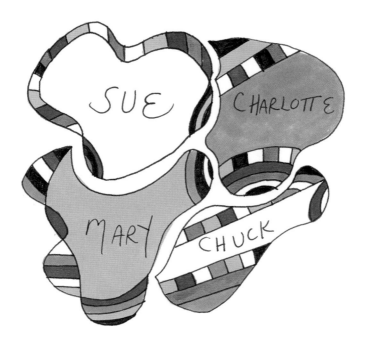

There is no order in which the drawing and coloring must be performed. Sometimes, I draw the entire prayer chart first, then return and color the images. This gives me a second chance to visit the people for whom I intercede.

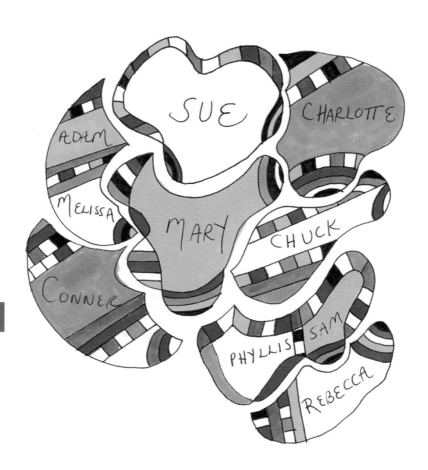

Draw with pen and colors until you have created an image or icon for all of the people for whom you want to pray. Linger with the page in front of you. Let the names, images, and colors imprint themselves on your brain. Spend another moment with each person in silence or say a short verbal prayer or "Amen" if that seems appropriate. Take the journal or page with you, if you can. Place it on your desk, refrigerator, or someplace where your eyes will scan it during the day.

Sometimes I include two people in one space—my children, a couple, my son and daughter-in-law, families who are traveling together.

When you are finished, do something physical or verbal to release the burdens of the people on the page. Be intentional about the release. It may not be useful or healthy to hold the suffering of others in our body.

A flash of the image in your mind during the day is a reminder that you have committed these persons to the care of God. It is also a reminder that you have chosen not to worry but to pray for them.

Whenever worry about a person seeps into your consciousness, picture them in color surrounded by the love and care you offered when you sat with them in prayer. Envision them in the care and presence of God. Act as if you really believe that God will take care of them.

The next day, you may choose to draw a new prayer icon. Or instead of creating a new one, enhance the original in several ways. Add other names to your community of color. Some of these names might be the family and friends of people already on the page. Make new shapes for them if space permits, or write their names nearby. Another way to expand the original drawing is to write specific requests, biddings, or thoughts near a person's name. Words may come after you have spent some time of silence with each person.

I use the word *icon* with the understanding that an icon is an image that helps us to see God. We do not worship the image; it has a transparency about it that lets us see through it to a deeper experience of God and God's presence.

As you pray throughout the day using the icon, words may come that help you to articulate and clarify your intercessions. If the words deteriorate into worried or quick-fix jabber, return to the visual, nonverbal images on the page.

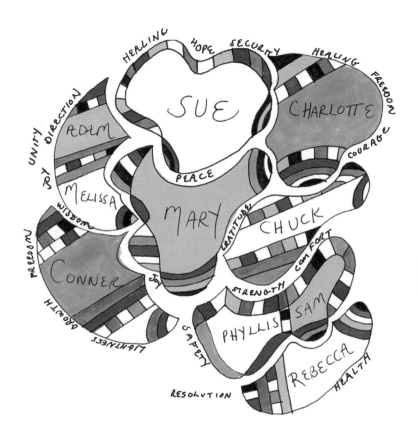

Chapter 4

Other Ways to Begin

If *praying in color* seems more like playing than praying, remember Jesus asks us to become childlike. "Truly I tell you, unless you change and become like children, you will never enter the kingdom of heaven" (Matt. 18:3 NRSV). Prayer and play are both about letting down our inhibitions and becoming childlike. In prayer we let down our inhibitions to let God in. If drawing is not in your skill set or the idea of drawing your prayers seems awkward, here are some ways to get started. The following examples suggest some formats for easing your way into *praying in color*.

There are an infinite number of ways to begin. Start with something as simple as a line.

Add flags or blossoms for names.

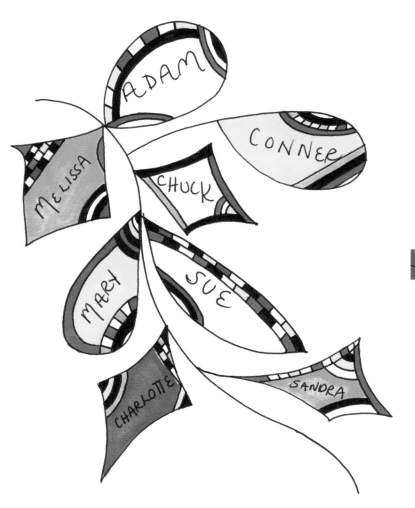

Start your prayers with God. Write one of the many names for God. Begin to draw and ask God to be present in your prayer. You can use words or just let your eyes and heart focus on the name you chose. Here are some of the many names we have:

Jesus *Holy Spirit* **God**

Healer Savior CREATOR FATHER

Abba Redeemer Lord **Father-Mother God**

We can add adjectives to the above names:

Loving God *Brother Jesus* Healing Savior Higher Power

Forgiving Lord **Almighty Father**

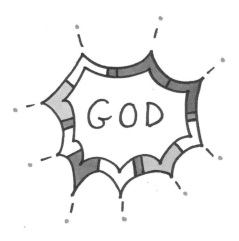

Then add people to the drawing, knowing they are in God's care.

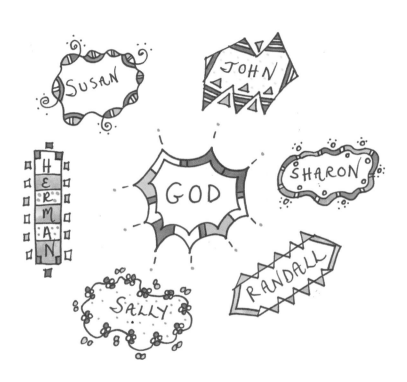

Write a person's name—or your own—and let the name instigate the movement and shape of the drawing.

Even a grid can host the people you want to pray for. The advantage of the grid is that there is built-in room for more names.

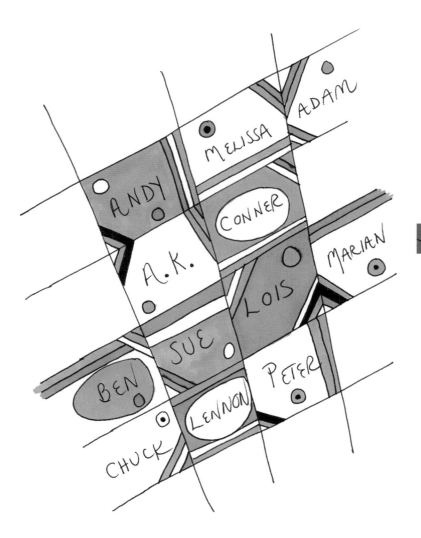

The hand, given free rein, will often create a wacky drawing.

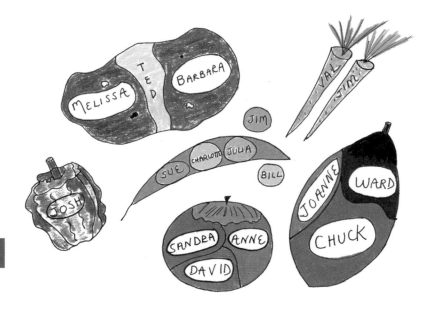

The first shape I drew looked like a potato, so everyone that day ended up inside of a vegetable. The downside of such a drawing is that friends might think you are a bit crazy if you tell them, "I prayed for you today and you were in an eggplant."

The upside for me was that I really remembered who I was praying for and where they were on the page. The whole point is to flood the memory with visual reminders and trigger unceasing prayer.

The word *irreverent* entered my mind as I drew. Intercessory prayer is serious and solemn work, but it can also be joyful and playful. When I pray, I release the burdens of my heart. Lightness replaces despair and sorrow.

Sometimes color feels unnecessary or wrong. Draw with just black pen and ink.

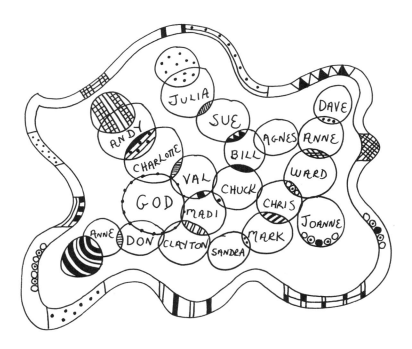

There are times when I've been too sad or too hurried to pick up the colored markers. Instead of trying to force myself to add color, I gave myself permission to just use pen. The result can be as distinctive and memorable as color.

There may be times when one person or one family is the focus of your love and concern. Don't hesitate to devote an entire drawing to a single person.

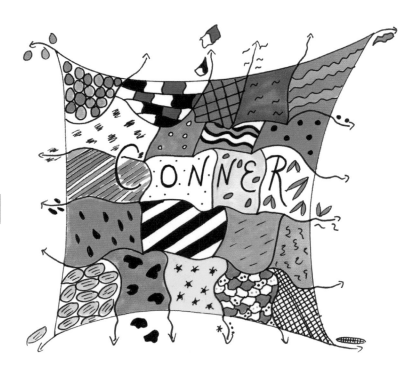

The image of God as a patchwork quilt came from my son when he was three years old. He described God as patches of every kind of skin, fur, shell, and feather of all creatures on earth. It seemed appropriate when I prayed for him that he be wrapped in a picture of that quilt.

Use a calendar template for your prayers. The squares create a boundary and a time limit for your drawing. The calendar reminds me to pray daily. It is a diary of my prayer intercessions and an ongoing prayer list.

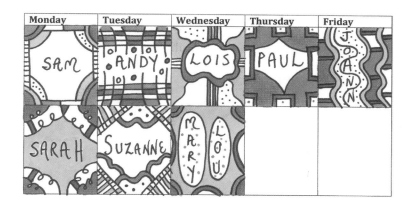

Use letters, numbers, or symbols to make your prayers. The young woman in the prayer below faced an important college math exam. It seemed appropriate to surround her with God's love and math symbols. Each variable, infinity, and square root felt like a prayer for her.

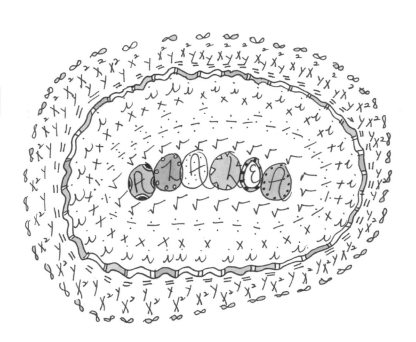

Pray on the computer. Use the draw menu or application instead of pen and markers. When you finish the prayer, save as it your screensaver. Send it as an email to friends. Post it on Facebook. Ask others to pray for the people on your heart.

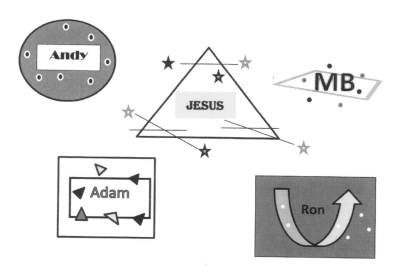

Take advantage of the drawing and doodling apps on your technology. Here is a prayer on an iPad using an app called SketchPro. Like the computer prayer, you can share it with others.

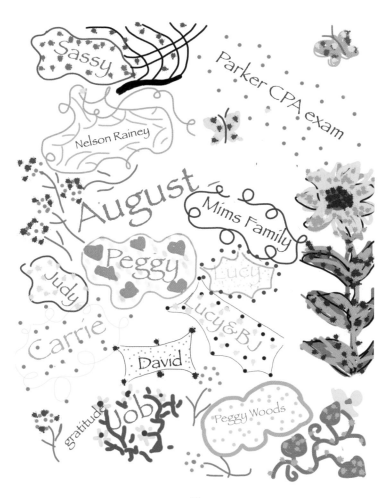

Write your name for God in the center. Draw straight or wavy lines out from the word. Then draw *U's* (or semi-circles) and *V's* in different positions for all of the other strokes. Add names as you go and pray for them as you draw.

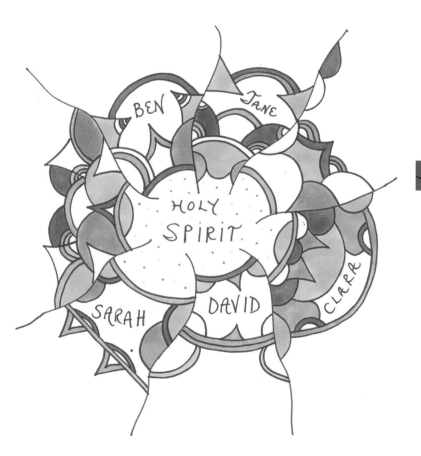

Use a ruler, Geometer™ or stencils[2] to help you draw. Remember praying in color is not an art contest. It is a way to keep your hands busy and your body engaged while you pray. It is a way to create a visual image reminding you to continue to pray. How you draw or with what tools you draw does not matter.

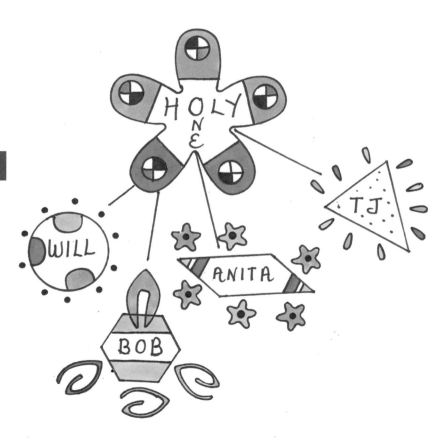

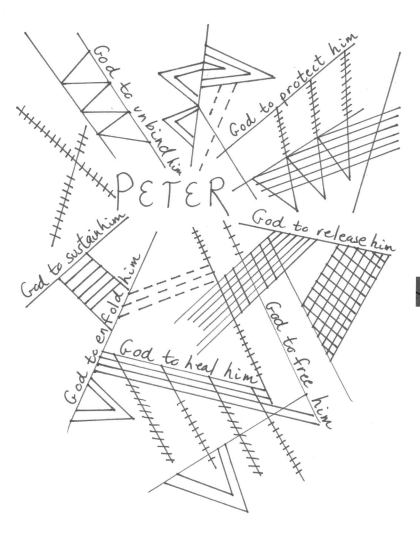

PETER

God to unbind him

God to protect him

God to sustain him

God to enfold him

God to release him

God to heal him

God to free him

3

Part 4 Using
Praying in Color to . . .

Make a daily gratitude list. This can be a general list or "What I'm grateful for in the past twenty-four hours." Draw around your hand or use a calendar and add a new gratitude each day.

Chapter 5

Spend Time with God

Create *some time* for just you and God. Write one of the many names you know for God and start to draw. Breathe. Tune in to listening mode. Enjoy the pleasure of being in the presence of God with no agenda. "For God alone my soul in silence waits; truly, my hope is in him" (Psalm 62:6 BCP).

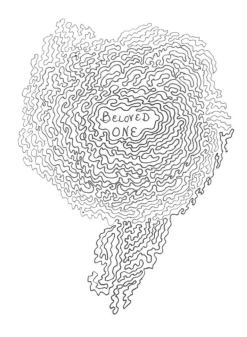

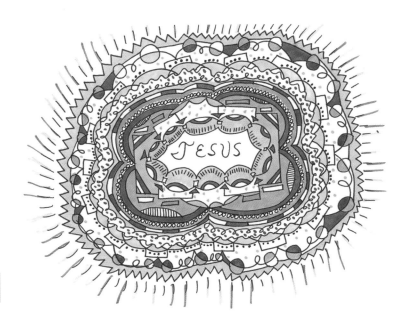

Draw an *Adoration* prayer. *Adoration* is one of the Church's many traditional prayer forms. (*Intercession*—prayer for others, *Petition*—prayer for ourselves, *Thanksgiving*—prayer of gratitude, and *Confession*—prayers of apology and for forgiveness—are examples of others.) In this prayer form we acknowledge the greatness and wonder of God. It is like a love letter to God. Another word for this kind of prayer is Worship.

I'm not very adept or at ease saying, "I love you," directly to God, so I like to write and pray words to honor the awesomeness of God.

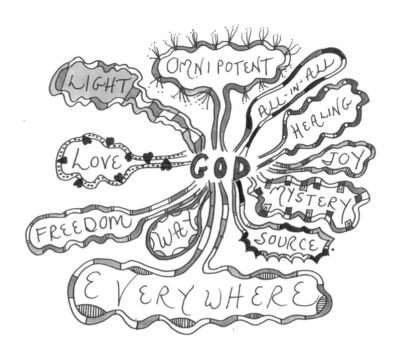

Have a *Conversation* with God. Start the conversation by doodling. Don't force words. If you have things you want to say, go ahead and say them. Maybe even write them down. When the words run out, continue to draw and be quiet. Let this time with God be ebb and flow between words and silence.

As someone who feels shy with God, I need time to collect my words, my thoughts, my petitions, my questions, and my praises. Drawing helps me bide my time until the words come and keeps me focused during the silences. Writing my words and the ones

I think I hear creates a record of my conversation and a source for future reference.

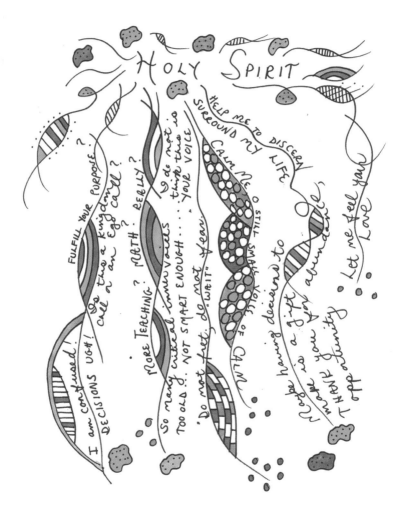

Chapter 6

Pray the Scriptures

Learn and memorize a passage from Scripture.

THE STEADFAST LOVE OF THE LORD NEVER CEASES,

HIS MERCIES NEVER COME TO AN END;

THEY ARE NEW EVERY MORNING;

GREAT IS YOUR FAITHFULNESS

"THE LORD IS MY PORTION," SAYS MY SOUL,

THEREFORE

I WILL HOPE IN HIM."

LAMENTATIONS 3: 22-24
NRSV

Write the first sentence or verse of the passage you want to memorize. Say it over and over again while you enhance the words with designs and color. When you can recite the words with ease and can visualize the words on the paper, move to the next verse.

When the new verse feels comfortable, put it together with the first verse. Say the two together, moving your eyes back and forth across the drawing. Continue the process until you have committed the entire passage to memory. This might take more than one sitting.

Pray the Scriptures using *lectio divina*. Analyzing, studying, interpreting, memorizing, reading, reciting . . . are all ways I engage the words of the Bible. But praying the Scriptures using an ancient Christian practice called *lectio divina* has transformed my relationship with the Bible and with God. In English, the Latin words *lectio divina* mean "divine" or "sacred reading."

Lectio divina is not historical study or critical analysis of a biblical text. It is a way to pray the Scriptures and to listen for the voice of God speaking to me at a particular moment in time. If Scripture is truly the Living Word, it will speak to me in new ways every day. In *lectio divina*, I ask God to speak the truth I need to hear.

Lectio divina is a four-part prayer form:

 Lectio means "to read."

 Meditatio means "to meditate."

 Oratio means "to speak or pray."

Contemplatio means "to contemplate."

Many of the teachings and books about *lectio divina* encourage sitting in a chair with a straight spine and upturned hands in the lap. This kind of stillness is agony for me. My hybrid version will give you permission to move. So gather your pen and paper and prepare a place to pray.

LECTIO: Choose a single line of Scripture. Select one that will be read in worship on Sunday or one that intrigues you. In a jam, open the Bible and point to a sentence. Here is an example:

A new heart I will give you, and a new spirit I will put within you; and I will remove from your body the heart of stone and give you a heart of flesh. Ezekiel 36:26 (NRSV)

Write the passage on a piece of paper. Write it large enough so you can really see it. Read it slowly. Read it five or ten times. Read it aloud if possible. Ask God to give you a word for the day. Read the passage over and over again until a word jumps out at you. When you have the word, circle it. (If no particular word cries out, just choose one at random.)

A NEW HEART I WILL
GIVE YOU, AND A NEW
SPIRIT I WILL PUT WITHIN
YOU; AND I WILL REMOVE
FROM YOUR BODY THE
HEART OF STONE AND
GIVE YOU A HEART OF
(FLESH).

I chose the word *flesh*. It is the word I will use for the rest of the prayer. In the next two sections I will ask God to speak to me through this word.

MEDITATIO means to "meditate, chew on, or mull over." My favorite definition is "marinate." I will take the word *flesh* and marinate in it. I will let it soak into my pores and listen for what it might have to say to me. I like to do this in two ways. You might try doing it on another piece of paper too.

 In the middle of a clean piece of paper, write the word you chose. Now write down everything you know about this word. Brainstorm; do a brain or data dump. Write down anything that comes to mind, even if it seems silly or far-fetched. What we're doing is clearing our minds of any preconceptions or thoughts we already have about the word. Some people call this *webbing* or *mind-mapping*.[3] You can quit when you've exhausted your ideas. You can also set a timer for three to five minutes and create a time boundary on your brainstorm.

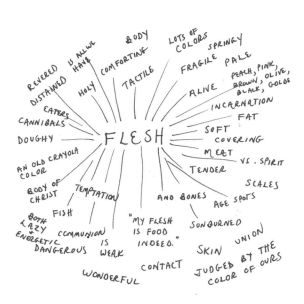

Now take a new piece of paper. Write your word again in the middle of the page. This time don't think about the word. Instead of teasing ideas out of your brain, listen to the word. Pretend it is a guest in your house. Let it speak to you. Listen for what God might say to you through the word. While you are listening, draw. Doodle around the word in the same way described in chapter 3. Let the movement of the hand help you focus on the word and release anxiety. Get still on the inside by moving on the outside. If you hear other things about the word, write them down. If the thoughts and words from the previous brain dump come back to you, write them down again. Use a timer, or stop when you feel finished.

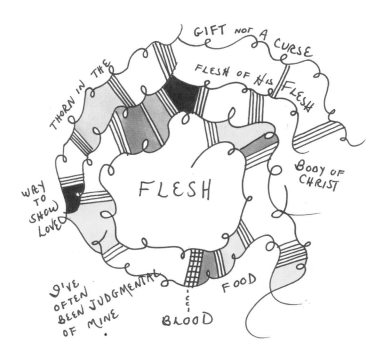

ORATIO means "to speak or to pray." In this part of *lectio divina*, we talk to God in the more traditional way of prayer. This is a chance to use words and have a conversation with God. We can ask God about the word we've been sitting with for the past ten minutes. "What do you want me to hear and learn from this word? Why is this word important today?"

Some practitioners of *lectio divina* use this time as a chance to express feelings to God. For some of us this is awkward. I'm not very good at verbal expressions of intimacy. I have trouble saying "I love you" even to the people I love. I'm shy with words of tenderness and care. Saying words of love and adoration to God is no less embarrassing. Maybe at the very least, we can be silent and imagine God loving us.

You can also see this time as a conversation with Jesus. I have friends who like to imagine Jesus sitting on a rock; they are chatting face-to-face. The face-to-face conversation seems way too scary to me. So I've imagined myself sitting back-to-back on a park bench with Jesus. It feels friendly, but not too intimate.

Even though this step is about oral conversation, I like to have my pen in hand. It can act as a little buffer between God and my shyness. Whether you're comfortable or not with this talking-to-God stuff, let your feelings and questions come to the surface. Write down your thoughts and questions: "Help my unbelief." "I'd like to know you better." "Open my heart." "Why this word, God?" While you talk and write, continue to draw. Drawing during this step helps me to focus and to listen. Writing helps me to see what I'm thinking and feeling. I might not "hear" anything, but creating this time and space for conversation with God prepares the soil of my heart for a response when it does come.

Take two to five minutes (or longer) with this step.

68

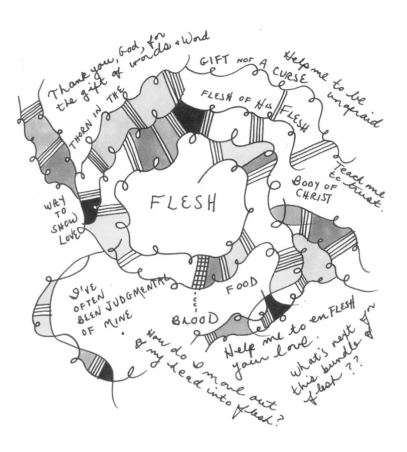

FLESH

Thank you, God, for the gift of words & Word

THORN IN THE

GIFT NOT A CURSE

FLESH OF HIS FLESH

Help me to be unafraid

Teach me to trust.

BODY OF CHRIST

WAY TO SHOW LOVE

I'VE OFTEN BEEN JUDGMENTAL OF MINE

FOOD

BLOOD

How do I move out of my head into flesh?

Help me to enFLESH your love

What's next this bundle of flesh ??

4

CONTEMPLATIO: This is the last step of *lectio divina*. I think of this step as the rest stop or the cool-down period before I go about the normal business of my life. *Contemplatio* is the step where I release the word I have chosen and all of the thoughts and feelings about the word. I give up all of the activity of drawing, thinking, and writing. I close my eyes, still my mind, and imagine myself falling into the huge hammock of God. Even as normally fidgety as I am, I'm ready for a couple of minutes of rest after the work of the previous steps. Being held by God feels like a pretty good way to spend a few minutes of my day.

So put down your pen. Set a timer for two to three minutes. Sit in a chair or lie on the floor. Close your eyes. Take a deep breath and release it. Stay in the moment. Let go of the past ten minutes; don't think of the next ten. Breathe.

Some people have huge spiritual "ahas" during this time. A new revelation about the chosen word breaks through the silence. Transformation happens for them. Other people just enjoy the rest and the quiet time.

My time with *lectio divina* never feels wasted. At the very least, I know more about the word I chose than ever before. And I never hear the word in exactly the same way again. During the *meditatio* I teased a lot of associations from my brain. I marinated in the word and listened to it. A week or a month later, it might come back to me with new relevance or insight.

Occasionally, I have a spiritual breakthrough. One time I read the Scripture verse I had chosen for a large group retreat. No word or words jumped out at me. Almost as a joke I picked three words: *but*, *no*, and *so*—not exactly meaty, spiritual concepts. I went through the four steps of *lectio divina*. A week after the retreat, those three words popped into my head and said, "You use us when you want to feel smart or superior. You keep your distance from other people with us." I saw myself with

crossed arms and a haughty look, "*But* have you thought of this option?" Or, "*No*, that won't do." Or, "*So* what?" It was not a pretty picture. But I knew it was true, at least sometimes. God had spoken to me through those three little words and told me something I needed to hear.

People ask, "Doesn't *lectio divina* take Scripture out of context?" My response is, "Yes." But that's not the point. *Lectio divina* is not the study of Scripture. It uses Scripture as a way to initiate a conversation with God. It only takes a single word to deepen our relationship and experience God's abundant and abiding love.

Save the sheets of paper with your prayer drawings on them. Put them where you can see them or where they are accessible. Store them in a notebook as a prayer journal. When we learn something from a prayer time, it usually takes a long time before we incorporate our insights and gleanings into our lives. Having a visual reminder of the words may speed up that process.

Lectio divina is a practice that takes practice. Do it a dozen times without asking, "Is this useful?" Prayer is not just about application and utility; it's about living full-time with God at the center. *Lectio divina* reminds us that living as a person of God is not about "getting" or "doing," it's about "being" in relationship with God. All actions are a subset of that relationship.

In his book *Read, Think, Pray, Live*, Tony Jones suggests a 30-minute *lectio divina*: 10 minutes for *Lectio*, 5 minutes for *Meditatio*, 10 minutes for *Oratio*, and 5 minutes for *Contemplatio*.[4] This is a helpful guideline, especially if the movement from one step to another does not seem obvious. On your first attempts, thirty minutes might seem like too much time. Build up to it gradually. Cut each of the suggested times in half at first. Soon, you just may find yourself hungry for more!

Chapter 7

Pray for Our Enemies

Praying for others is an act of hospitality. It involves opening the door of our hearts and minds and admitting people into our consciousness. We invite them to take up residence for a time and allow them to engage our feelings and thoughts. Like entertaining guests for a weekend, praying for others requires time and energy. It is a way of saying, "Yes, I will hang with you and support you in your challenges and your suffering."

In Matthew's Gospel Jesus tells us, "Love your enemies, bless them that curse you, do good to them that hate you, and pray for them which despitefully use you, and persecute you" (Mt. 5:44 KJV).

Praying for his enemies was just another example of the radical hospitality that Jesus practiced. He invited people of questionable character and occupation to share meals with him. He let a woman—and even worse, a woman of sketchy repute—wash his feet and rub them with oil. He touched and healed the unclean. He opened his heart and life to men, women, and children that we would not even notice on the street.

Praying for our friends and loved ones is one thing. Offering the same kind of hospitality to our enemies is a lot to ask. Praying for the people who irk us, the people who hurt us, or the people we dislike or even hate is difficult because we do not want to think about them, let alone permit them to enter the sacred privacy of our prayers. We want to avoid our enemies, to forget that they exist. Even saying their names gives them a prestige we do not want them to have. Hospitality is out of the question.

When my husband and I moved to a new house in a new town some years ago, my next-door neighbor was all about hospitality in the traditional sense of the word. She brought us brownies within hours of our arrival. She offered us tools, meals, a chaise lounge in her backyard—anything that would make us feel welcome and ease the hassles of moving.

In the first weeks after our move, I noticed a parade of people coming to her house. She hosted a prayer group, a Third Order Franciscan gathering, and meetings of social justice committees. A fascinating assortment of individuals came for prayer and spiritual direction. What I didn't know then was who else she had invited into her life.

At age 94, my neighbor's great-aunt was raped and murdered. She had walked in on the burglary of her apartment and was stabbed multiple times. The man responsible was convicted of first-degree murder and

sentenced to death. For thirty years, he has been on death row. For thirty years my neighbor has prayed for him. Those prayers led her to initiate communication with him. Over the years they have exchanged letters. She has visited him at the state penitentiary. Her encouragement has led him to write and publish poetry.

My neighbor's hospitality has changed her life. She could have opted to blot the event out of her mind. She could have cultivated a justifiable hatred for the man who murdered a beloved relative. But she didn't. Her prayers and her efforts have resulted in several stays of execution and a resentencing hearing. She now speaks in public against capital punishment.

My neighbor's hospitality has also changed the man in prison. He has not become a saint or a man we would want as a neighbor, but he has been seen as someone worthy of the prayers and time of another human being. From a Christian as well as a quantum physics perspective, the way we as observers see something changes the observed. Just by looking at a quark, an atom, or a person, we alter them. Seeing a person as a child of God and praying for them changes both the person we pray for and us in ways that we cannot plan or predict.

Using markers and pen does not make praying for enemies easier than other prayer practices. It will probably not feel at all relaxing or playful. Writing the names of people you dislike or who "spitefully use you and persecute you" (Mt. 5:44 NKJV) can be a big step. It may turn your stomach. Unlike the verbal prayers you say, the name does not vanish into the past once it has been spoken. It sits on the page and stares back at you as you draw and color. Instead of the person's name, you can also write initials or a coded version of the name. In case someone stumbles on your prayer drawing, this can protect the anonymity of the person as well as your feelings.

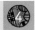

When my neighbor prays for her enemies, she makes two columns on a piece of paper, one for the left brain (the analytical and logical side) and one for the right brain (the intuitive and creative side). In the right-hand column she puts the person's initials or code name and draws. When thoughts or words come into her head about the person, she jots them down in the left-hand column. These might include feelings, things to dislike about the person, or things to admire about the person.

Negative and angry thoughts about the person may challenge your hospitality. Write them down; then arm yourself with a one-line prayer or Scripture passage to counter the challenges. Here are some examples:

"You strengthen me more and more; you enfold and
comfort me." (Ps. 71:21 BCP)

"When we extend our hand to the enemy who is sinking in the abyss,
God reaches out for both of us. . . ." (Thomas Merton[5])

"Forgive us our sins, for we also forgive everyone who sins
against us." (Lk. 11:4 NIV)

"There is nothing I cannot do in the One who
strengthens me." (Phil. 4:13 NJB)

". . . God shows his love for us in that while we were yet sinners
Christ died for us." (Rom. 5:8 RSV)

You can say the words to yourself over and over as a mantra or write the words in one or both columns of the drawing.

When you are finished, if you can stand it, hang the icon in a prominent place. Whenever you see it, remember the person as a child of God. If the temptation comes to use it as a dartboard, shoot a dart prayer at it instead.

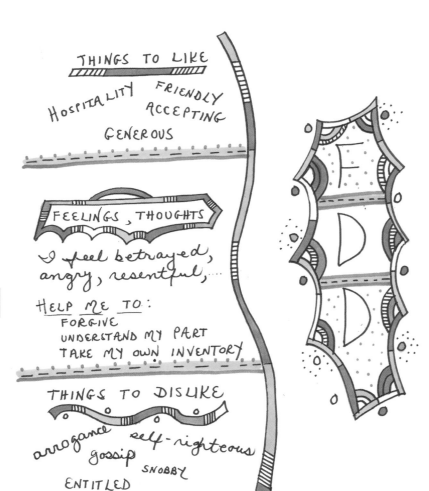

THINGS TO LIKE

HOSPITALITY FRIENDLY
 ACCEPTING
 GENEROUS

FEELINGS, THOUGHTS

I feel betrayed,
angry, resentful, ...

HELP ME TO:
 FORGIVE
 UNDERSTAND MY PART
 TAKE MY OWN INVENTORY

THINGS TO DISLIKE

arrogance self-righteous
 gossip
 SNOBBY
 ENTITLED

Chapter 8

Pray In Other Ways

Although intercession was the struggle that inspired *Praying in Color*, there are other kinds of prayer and spiritual brainstorming that fit well into this form. The possible ways to use this practice are as endless as our needs and our imagination. Here are some other ways to pray in color.

Compost prayers

God can handle whatever we bring to prayer. Some days we just want to dump all of our complaints, whining, grumpiness, and misery on God. Have at it! Write all of the negative things you can think of on your prayer drawing. Don't hold back. God can take our garbage and turn it into compost. Hang onto the prayer for a day, a week, or a month; then, if you have a compost pile, bury it there.

Thanksgivings

Fill the page with the many things for which you are thankful. A gratitude icon and a compost prayer icon go hand in hand. We can be grateful and grumpy with a God in whom we trust. Listing our grievances one time and our thanksgivings another shows an effort to have an honest and intimate relationship.

Amends

Think of the people to whom you need to make amends, to make apologies, or to ask for forgiveness. Write the names of these persons and the wrongs committed. Use the prayer drawing as a way to rehearse making the amends or apologies. Doing this in person may or may not ever be possible, but the act of confessing on paper might result in unexpected resolution. When we invite God into the process, clarity and cleansing can happen.

Spiritual Journey or History

Create a drawing that is a map of your personal journey with God. Include small, seemingly unimportant flickers of God as well as soul-blasting conversion experiences. Each step will probably trigger other memories and help you see other ways your life has been infused with God's presence.

Mentors

Catalog and celebrate the people who have helped you in your spiritual life. Sunday school teachers or pastors might be on the list, but think of the less obvious people who have helped you to see yourself as a love-worthy child of God. Sometimes mentors are the people who tell us the truth: a teacher who has kicked us off our complacent duffs or a friend who tells us we are acting like a turkey.

Remember adults who have encouraged us in a way that our parents could not. Sometimes other adults can see our gifts in a way that our own parents cannot. Parents are often scared for their children's safety and want to maintain the status quo. They want other people's children to become poets or social workers or relief workers in the Sudan. As a parent I understand the fear. As a child I wanted to be able to dream myself into

a whole host of uncertain vocations. Other adults, either because of their particular expertise or because they saw us anew, might have helped us envision ourselves in new ways.

Personal Mission Statement

Use words, drawing, and color to help verbalize and visualize who you are, whose you are, and what is important to you.

Healing of Memories

Most of us harbor old wounds and hurts that keep us bound and resentful. Use this process to articulate those wounds, to face them, and to face them down.

Names for God

Put some or all of the names we call God in your drawing. Let the drawing become a meditation on the way we understand and expand our knowledge of God. Maybe a particular name will speak to you.

Vocabulary

Christianity has its own jargon. Sit with a word or words from your tradition. Words like *salvation, forgiveness, incarnation, sacrifice—* loaded and heavy words.

The following pages show even more ways to use this practice.

Make a visual gratitude list. This can be a general list or "What I'm grateful for in the past twenty-four hours." Draw around your hand or use a calendar and add a new gratitude each day.

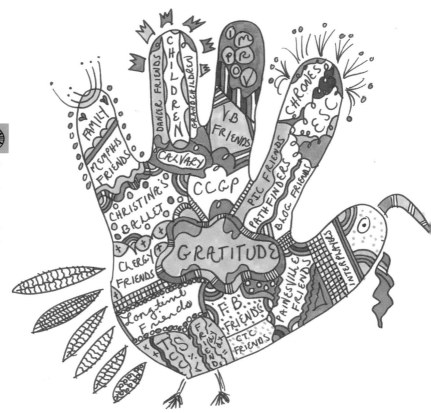

Use a calendar to create a daily discipline for Advent and Lent. Pray for people or pray the special words related to those seasons of the Church year.

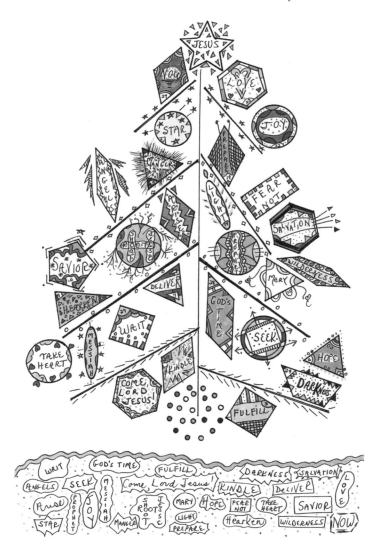

LENT

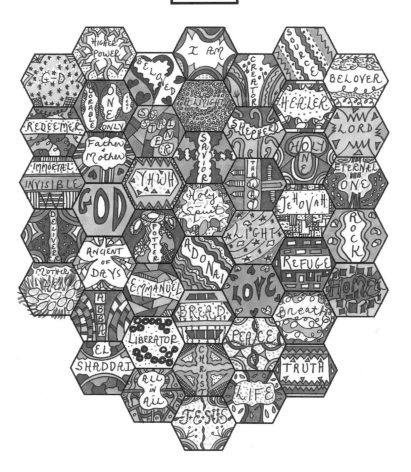

Part 5

A Palette of Final Thoughts

Chapter 9

Four Questions about
Praying in Color

Why might *praying in color* be right for me?

Praying in color is a way to pray when your body is restless and your mind wanders. It is a way to invite your body and your senses into your prayer time. The drawing and doodling give the eyes a place to look. The movement of the hand and the emerging drawing help to focus attention. Doodling gives the kinesthetic and visual learner something to do to quiet the body, still the mind, and create a receptive time and space where God can enter.

Praying in color is a way to pray when words won't come. When I most need words they often escape me. *Praying in color* sits me in a chair and gives me the settling time I need to gather my thoughts and to find words. If words come I do not chase them away; I pray them. Sometimes no words come. Each stroke of my pens and each movement of my hand on the paper bring a holy silence instead, and I know I am in God's presence.

Praying in color is a way to pray if you are just looking for a way to expand the prayer repertory you already have.

Is *praying in color* really prayer?

I sure hope so; I've been *praying in color* for almost ten years. Other than the words of the Lord's Prayer in Matthew 6, there is very little concrete instruction in the Bible about how to pray. Matthew 6 also warns against babbling a lot of words or trying to impress God with our words. I think God gave me permission to pray in a way suited to my personality and learning styles.

When I *pray in color* I try to still my mind and body so I can be open to words—my fumbling words and God's words to me. When I started praying in color I found a way to pray for others. I did not expect to also find a way to just listen to God. But this has been a way for me to pay attention and really listen to what the Holy Spirit is trying to say to me.

Is doodling the only way I pray? No. I still pray with words, my own or the prayers of my tradition. I am still a prayer popper. And I sometimes fall on my knees with no pen or markers in hand.

If I am actually an artist (not a mere doodler), will *praying in color* still work for me?

Sure. If you like to draw realistic or representational images, go ahead. Create a landscape or a still life or a beautiful drawing while you pray. Use pencil, marker, or whatever medium you like. Include the names of the people on your prayer list in the drawing. One artist told me, "I concentrate on the drawing so much, I lose my focus on the prayer for the person." If this happens to you, don't worry about it. Complete the drawing and use it as a prompt to pray.

What if I'm not sure I even believe in God or that God cares about my individual life and concerns? Will *praying in color* help me?

Praying in color does not presume any particular doctrine or any particular level of belief. Even committed Christians have occasional doubts about God's interest or attention. *Praying in color* does not demand words or an articulate vocabulary of the pray-er. When I was at my most scared and worried, I had no words to offer. *Praying in color* helped me to be still and listen for the God I hoped was there. It is a way to prepare the soil of my heart for possibly receiving the touch of a power greater than myself. Getting still on the inside helps me to believe that "the kingdom of God might really be within me." (based on Luke 17:21)

If you don't like the word *God* or the other traditional Judeo-Christian names people use in their prayers, try new ones; make up new ones—Higher Power, Infinite One, Longed For, Divine Presence, Source. . . .

Chapter 10

Praying in Color Tidbits

Try different sizes and shapes of paper for your prayers. Here are some suggestions:

- Backs of business cards

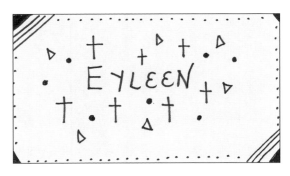

- Artist trading cards

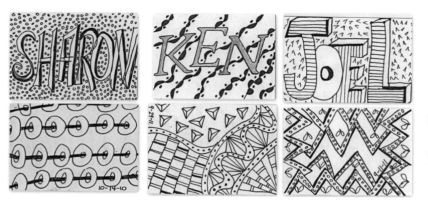

- Sticky notes

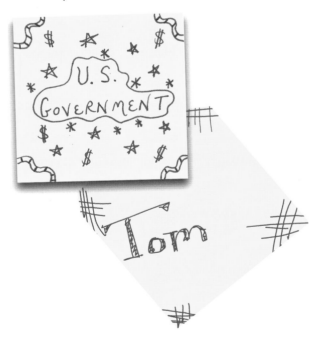

● Paper napkins

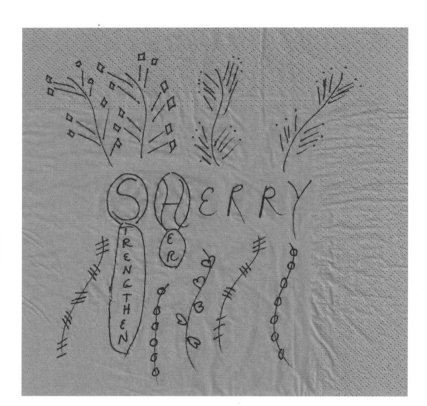

- Graph paper

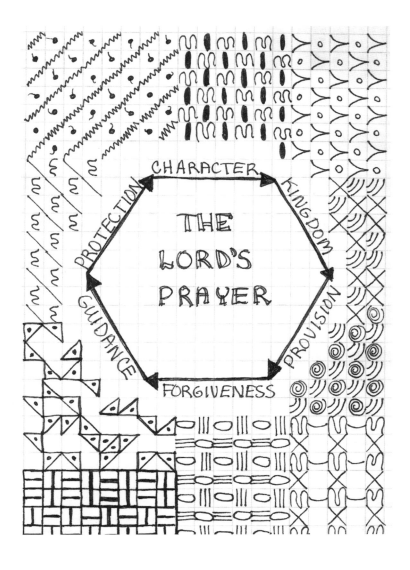

 Carry a pocket or purse-size notebook or notepad for impromptu prayers. With a pen and a notebook, any place can be a prayer closet. When I hunker over my notebook, people usually assume I'm doing something personal or working; they don't interrupt me. I pray in the doctor's office, on the plane, in a restaurant waiting for my food to arrive—anywhere and anytime I feel worried, grateful, sad, or just need some God time.

 If someone asks you to pray for them, doodle a *praying in color* prayer for them. If it seems appropriate, send the prayer to the person via snail mail; or scan it and email or text it to them.

 If too many color choices become a distraction from the prayer, just close your eyes and grab three markers (or pencils, or whatever) from your stash. Let those be the colors of your prayer for the day. You might just remember the prayer better because it is not your usual palette.

Check out my blog for new ideas and ways to use *Praying in Color*: http://prayingincolor.com/blog

Chapter 11

Praying in Color with Others

 Praying in color with a group can create a powerful experience of community, support, and worship. Jesus promises, "For where two or three are gathered in my name, I am there among them" (Matt. 18:20 NRSV). Praying with a pen and markers in hand gives people a safe way to come together in silence and listen to the Holy Spirit.

A group of two or three people can be a huge support while waiting for a friend or loved one in the hospital. When my husband was in the hospital, two friends and I sat in the cafeteria and *prayed in color*. I felt ease, serenity, and gratitude during the surgery.

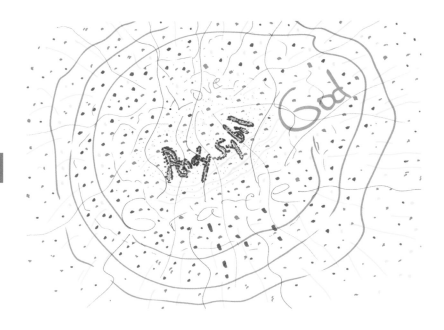

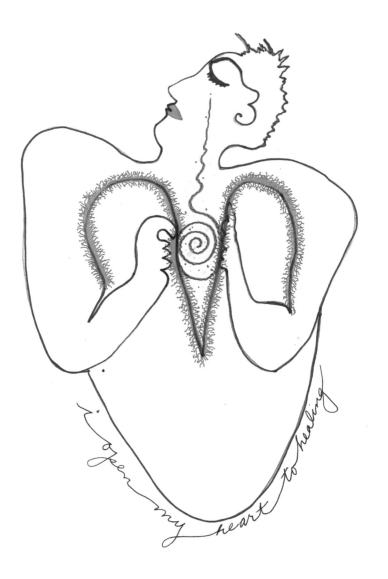

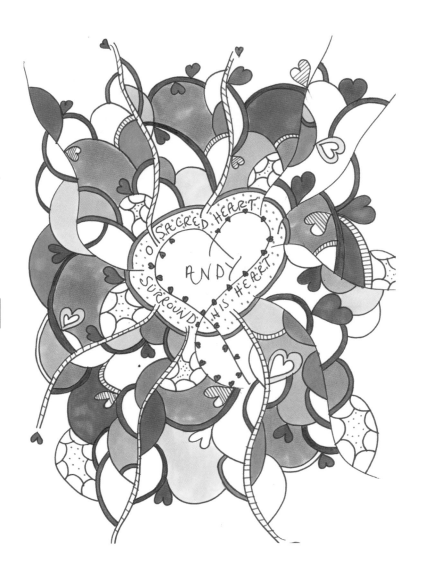

Create a *praying in color* wall at your house or church. Use a white board or white paper to allow others to post their prayer concerns for people to see. Provide markers, pens, sticky notes, long sheets of paper . . . whatever works in your space and community.

Start your church meetings with a *praying in color* prayer time. Read a passage of Scripture. Ask people to draw or doodle in silence with hearts and ears open to the Holy Spirit. This gives members of the group a chance to visually "park" the emotions, worries, and baggage they bring with them. It also provides an opportunity to open their minds and hearts for the business at hand. The atmosphere of quiet and submission to God can change the way a group deals with its vision, its decisions, and its mutual care and respect.

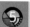

Try *praying in color* at home as a family. You may already have times of family prayer. Try *praying in color* around the table; that way, not only will more than one person be "talking" to God, but also you will have a lot to talk about with the kids once everyone is finished with their *praying in color* prayers.

Chapter 12

For You, the Reader

"Pray as you can, not as you cannot" are the liberating words of nineteenth-century Catholic priest and theologian Dom John Chapman. Drawing with pen and markers is the way I can pray right now. I am grateful for all of the people in my life who taught me various ways to pray and who lined up on the path to cheer me along. They set me free to see the many ways people reach for God.

Praying in Color may or may not be your way to pray. At the very least, I hope it gives you a mustard seed-sized kernel to find a new path of prayer.

notes

1. Thomas Merton, *Seeds of Contemplation* (New York: New Directions Publishing Corporation, 1986), 140.
2. Stencils used for the colored drawing are two sets of Pebbles Stencils called Accents and Flowers. www.pebblesinc.com
3. The term *mind-mapping* is often attributed to Tony Buzan, a British psychology writer and consultant. The idea of brainstorming has been around for centuries. For years I have collected and collated thoughts, feelings, and information using this method.
4. Tony Jones, *Read, Think, Pray, Live* (Colorado Springs: NavPress, 2003), 126.
5. Thomas Merton, *The Hidden Ground of Love* (New York: Farrar, Strauss, Giroux, 1985), 141.

In Chapter 6, pages 64–71 are excerpted and adapted from Chapter 12 in *Praying in Black and White: A Hands-On Practice for Men* by Sybil and Andy MacBeth.

acknowledgments

I owe thanks to many people whose contributions brought the original *Praying in Color: Drawing a New Path to God* and now this *Portable Edition* to print: to friends who read parts of my manuscript and made helpful suggestions, especially Lynn Hunter, Suzanne Henley, Ellen Klyce, Marybeth Highton, and Page Zyromski; to the people who shared examples of their prayer drawings in this new edition: Margaret Craddock (page 44), Lisa DiScenza (page 52), Connie Denninger (pages 89 Artist trading cards, 91), Randall Mullins (page 94), and Sharon Pavelda (page 95); to the staff at Paraclete Press who welcomed yet another *Praying in Color* project with enthusiasm: my editor Jon Sweeney, the production team with Bob Edmonson, and the Paraclete Press design team.

I am especially grateful to Phyllis Tickle, who encouraged me to write the original book, mothered me through the process, and continues to urge me to write; to my husband, Andy, who lovingly reads and re-reads my manuscripts and blog posts at all hours of the day and night and spends many weekends alone while I present Praying in Color Workshops® and retreats around the country; and to the many host churches and organizations who have shown me true Christian hospitality and openheartedness over the past six years.

about Paraclete Press

who we are

Paraclete Press is a publisher of books, recordings, and DVDs on Christian spirituality. Our publishing represents a full expression of Christian belief and practice—from Catholic to Evangelical, from Protestant to Orthodox.

We are the publishing arm of the Community of Jesus, an ecumenical monastic community in the Benedictine tradition. As such, we are uniquely positioned in the marketplace without connection to a large corporation and with informal relationships to many branches and denominations of faith.

what we are doing

Books

Paraclete publishes books that show the richness and depth of what it means to be Christian. Although Benedictine spirituality is at the heart of all that we do, we publish books that reflect the Christian experience across many cultures, time periods, and houses of worship. We publish books that nourish the vibrant life of the church and its people—books about spiritual practice, formation, history, ideas, and customs.

We have several different series, including the best-selling Paraclete Essentials and Paraclete Giants series of classic texts in contemporary English; A Voice from the Monastery—men and women monastics writing about living a spiritual life today; award-winning poetry; best-selling gift books for children on the occasions of baptism and first communion; and the Active Prayer Series that brings creativity and liveliness to any life of prayer.

Recordings

From Gregorian chant to contemporary American choral works, our music recordings celebrate sacred choral music through the centuries. Paraclete distributes the recordings of the internationally acclaimed choir Gloriæ Dei Cantores, praised for their "rapt and fathomless spiritual intensity" by *American Record Guide*, and the Gloriæ Dei Cantores Schola, which specializes in the study and performance of Gregorian chant. Paraclete is also the exclusive North American distributor of the recordings of the Monastic Choir of St. Peter's Abbey in Solesmes, France, long considered to be a leading authority on Gregorian chant.

Videos

Our videos offer spiritual help, healing, and biblical guidance for life issues: grief and loss, marriage, forgiveness, anger management, facing death, and spiritual formation.

Learn more about us at our website:
www.paracletepress.com,
or call us toll-free at 1-800-451-5006.